I'm New at Being Old

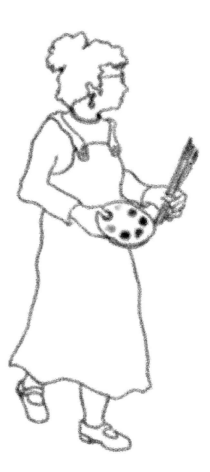

I'm New at Being Old

ART AND NARRATIVE BY Lucy Rose Fischer

Temuna Press
MINNEAPOLIS, 2010

ISBN 978-0-615-33519-3

Library of Congress Control Number: 2009941512

9 8 7 6 5 4 3 2
First Edition

Printed in China

Cover design: Kyle Hunter
Interior design: Rachel Holscher
Editor: Phil Freshman
Author photo and art photography: Sid Konikoff
Publication and production management: Jim Bindas, Books and Projects LLC
Published by Temuna Press, Minneapolis

Distributed by:
Itasca Books
5120 Cedar Lake Road
Minneapolis, MN 55416
Phones: 952-345-4488/1-800-901-3480
Fax: 952-920-0541

Copies of this book can be ordered at:
www.temunapress.com
 or
www.lucyrosedesigns.com

To Mark

I'm venturing into outer space, traveling toward an alien universe . . .

 The Galaxy of the Old Ones.

My baggage is stuffed with younger versions of myself.

Am I ready for this journey?

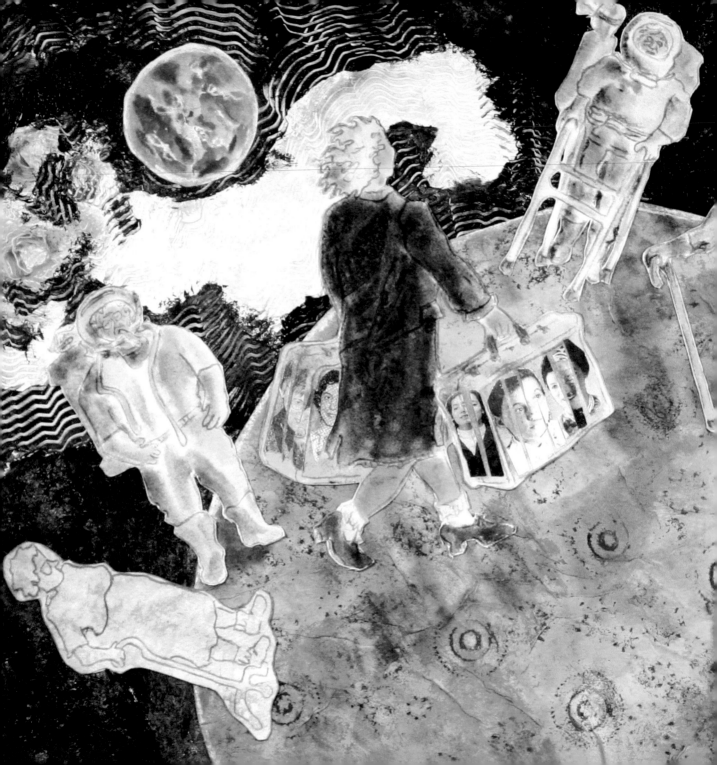

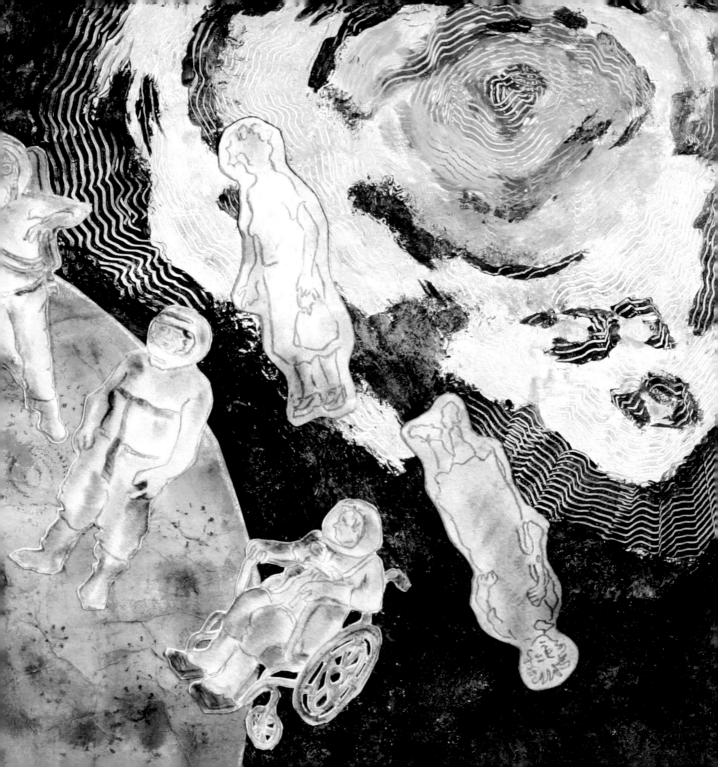

When I was younger, I was an expert on aging.

I directed studies and wrote books and articles.

I won awards.

I lectured to students who had no notion that growing old had anything to do with them.

Then, all at once, I begin to notice—a crease over my left eyebrow, extra flesh on my neck, gray strands of hair . . .

Why am I surprised?

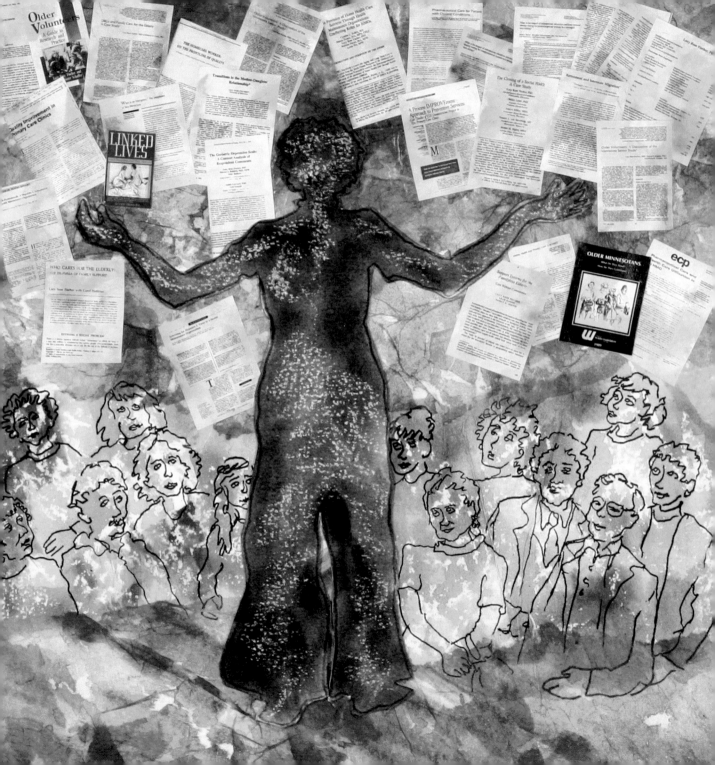

In my 50s, with fibroid creatures growing inside my uterus, I have a hysterectomy.

The surgeon says, "They are like grapefruits." Or maybe large pears? Or apples?

So this has become the fruit of my womb.

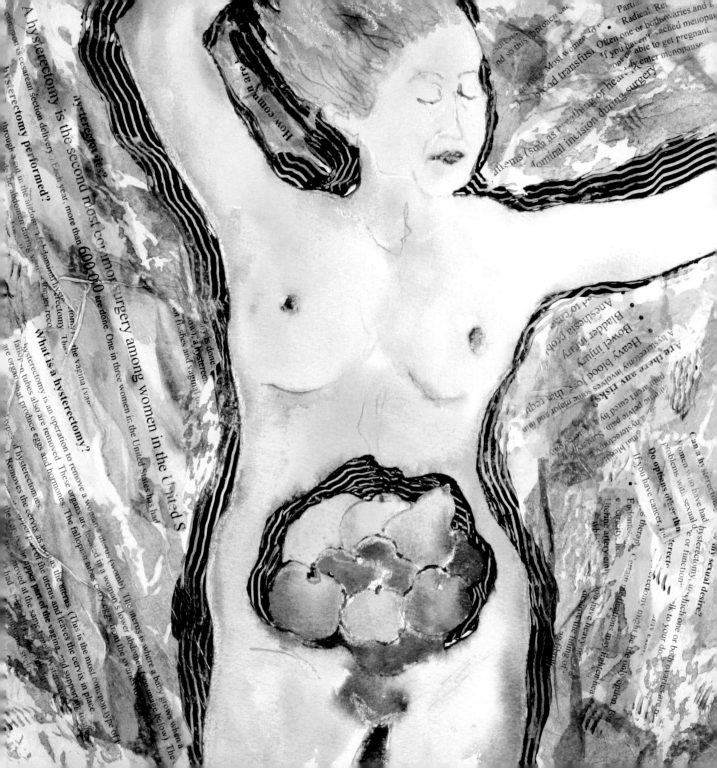

Abruptly, I enter woman-pause.

Abandoned by familiar hormones, the chemistry of my body churns and erupts.

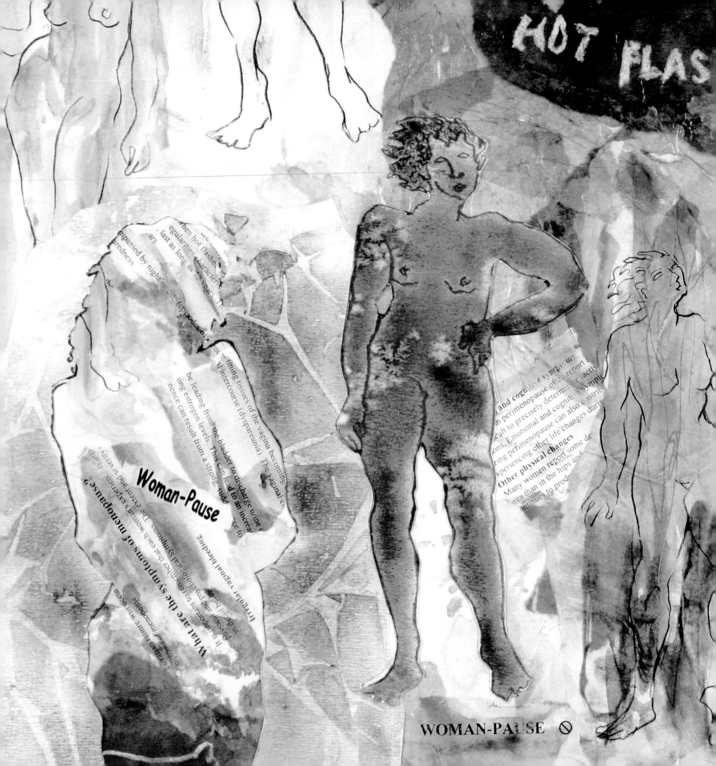

HOT FLAS

Woman-Pause

What are the symptoms of menopause?

WOMAN-PAUSE ⊘

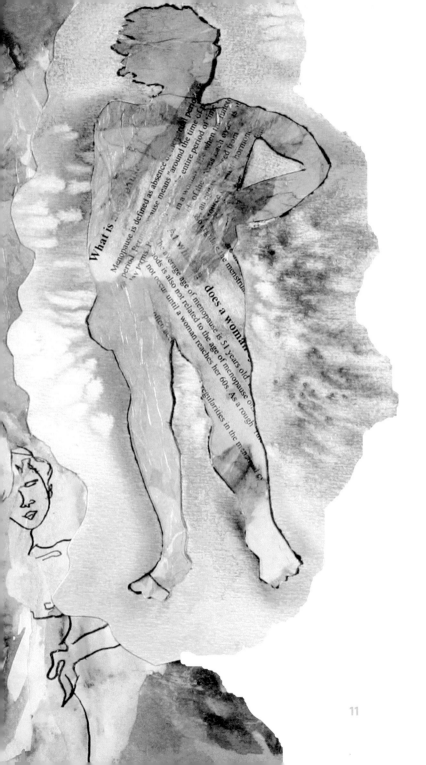

Like an overheated motor,

my body becomes

hot-flushed/hot-flashed.

How long will this go on?

At night I ask my love, "Is it warm here? Or is it me?"

All through the night: hot . . . cold . . . cold . . . hot . . .

Cold—I pull a blanket up to my neck.

Hot—I throw off the blanket and sheet, which now feel clammy, full of sweat.

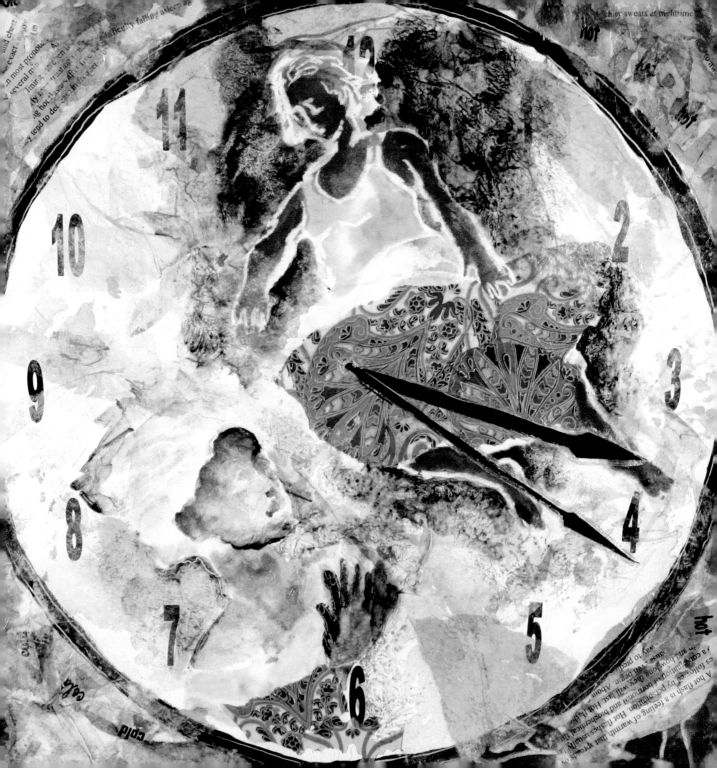

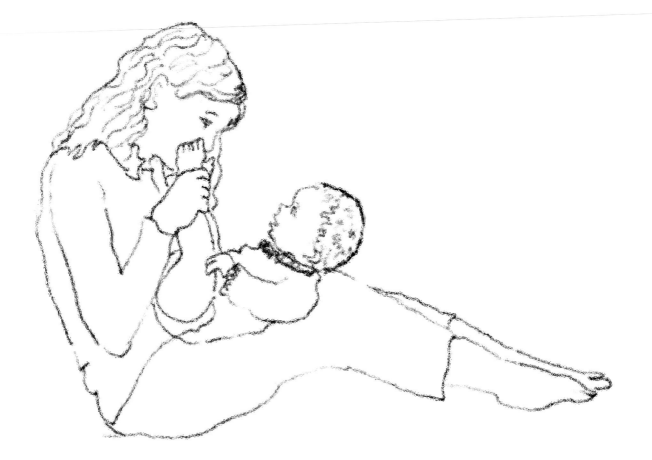

Was it just yesterday when I was a young mother?

I read stories to my baby before he knew what words were.

I loved to kiss his soft skin and curly feet.

Having a baby was exhausting, overwhelming, and sweet.

Suddenly my baby, my little boy, became his own person.

Now I'm a grandmother—even more delicious!

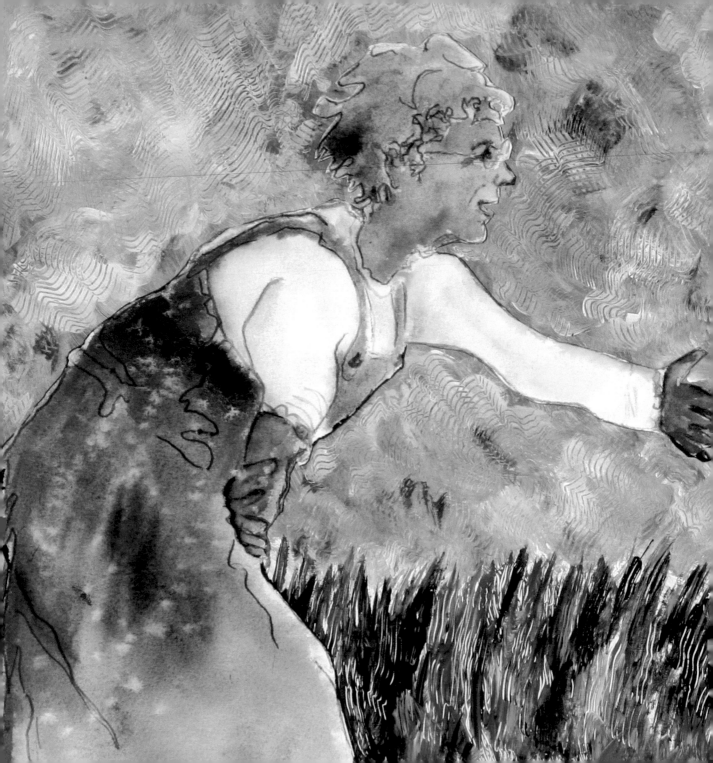

I board a crowded bus one day and say to myself,

"If someone gets up and offers me a seat, then I'll really know I'm old."

At just this moment, a young woman jumps up, insisting I take her seat.

My mother-in-law lives in a senior-housing apartment building.

When I go to visit her, a stranger asks me, "Are you new here?"

I'm nonplussed. Everyone here is 80 or 90 or 100 years old.

Inside myself, I'm a young girl with double ponytails.

I'm a teenage girl dancing in a red silk dress.

I am, still, a young woman full of dreams.

I am . . .

I am . . .

I am?

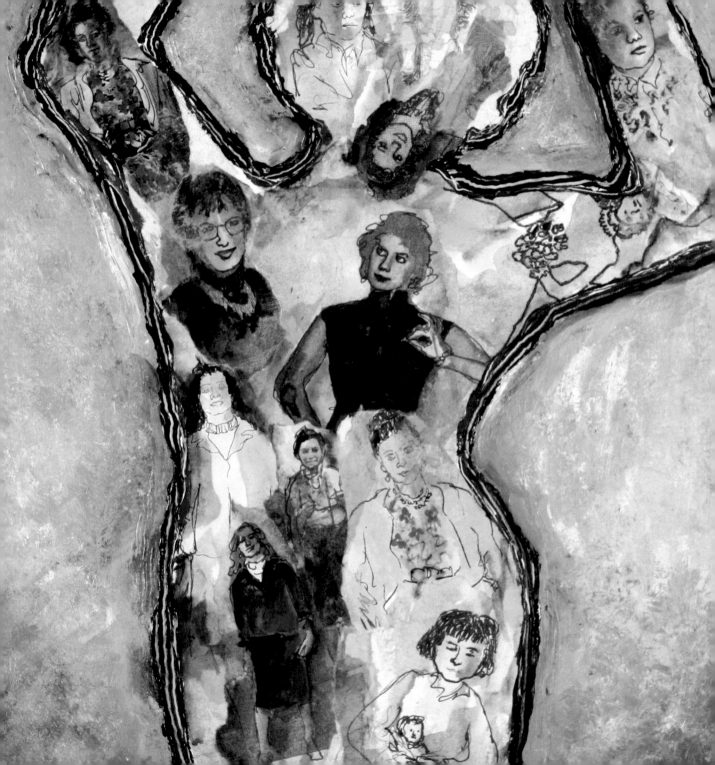

Sometimes, younger people seem to regard mature women like me as odd specimens of a different species.

—

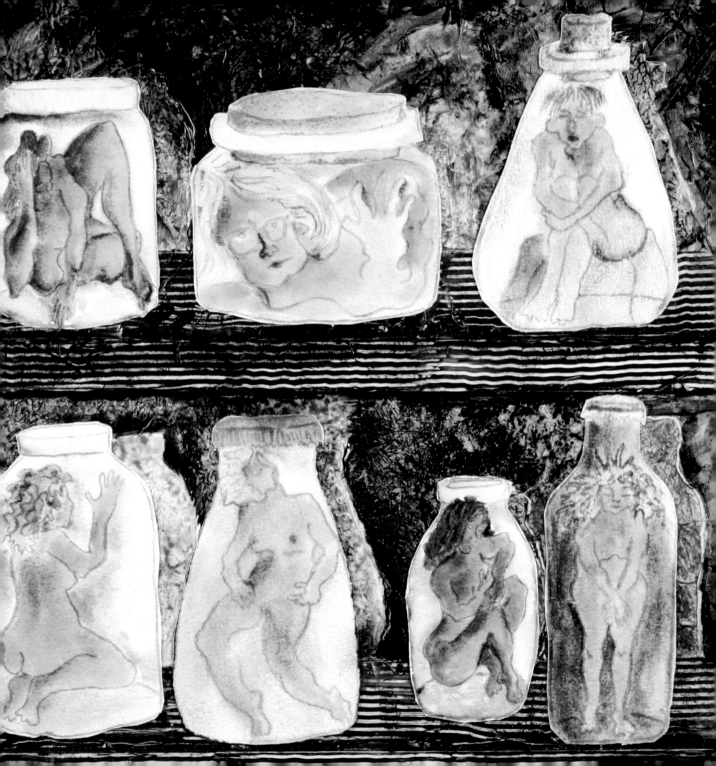

Or are we invisible, transparent 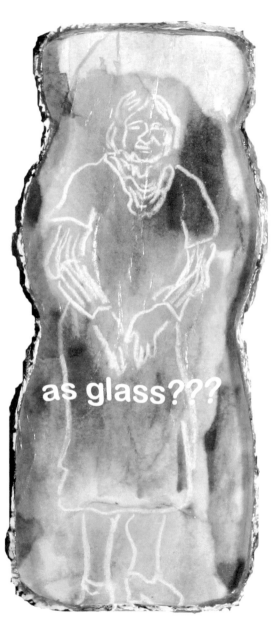 as glass???

When I get up in the morning or when I sit for a long time, my knees creak and ache.

It's beginning now—the breakdown of movable parts.

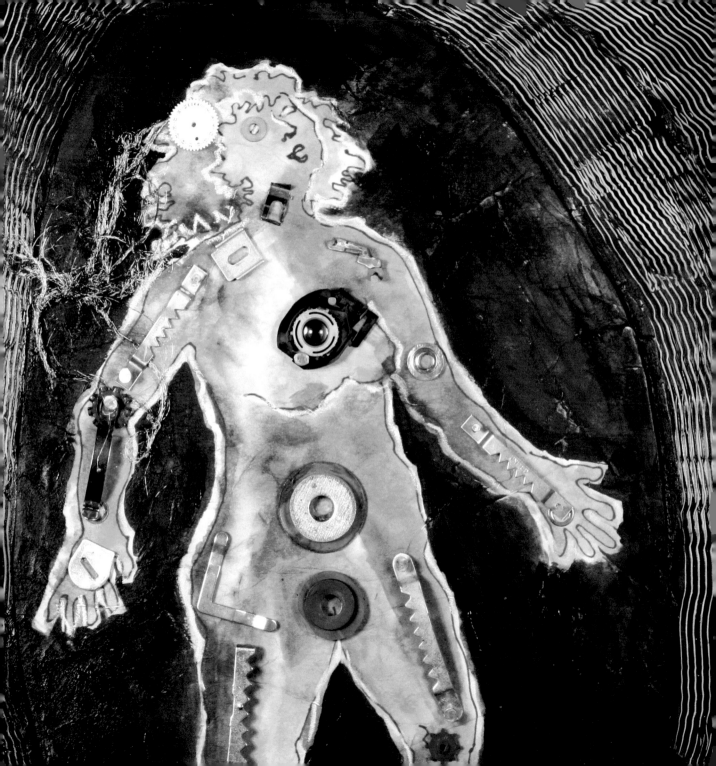

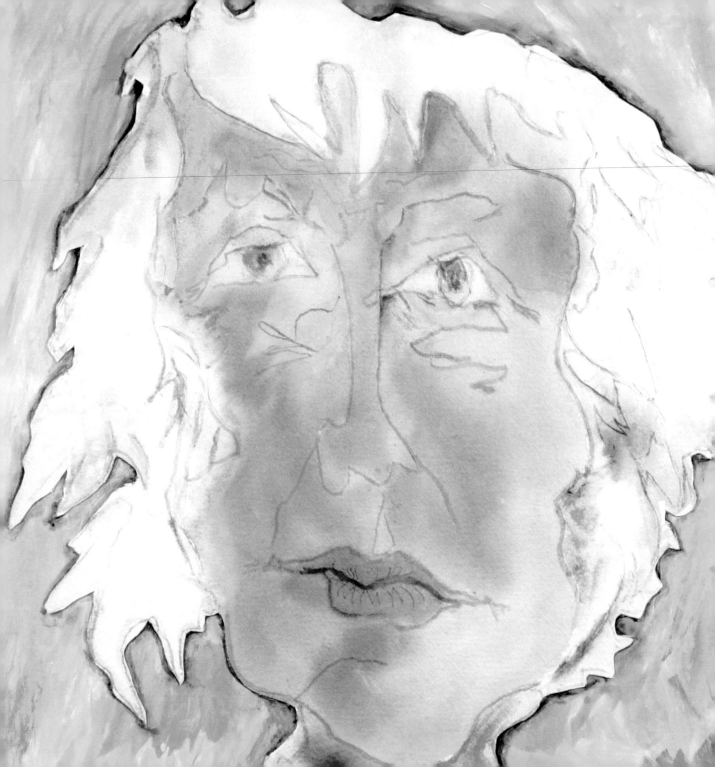

Some mornings, I study my face in the mirror.

Expressions of surprise or consternation are lodged on my forehead and around my chin.

I have nothing good to say about these thick and heavy creases.

But the crinkles above my lips remind me of a cat's whiskers, and the slender pleats near my eyes are soft and tender.

I rather like these fine, feathery wrinkles.

Someday, with luck, my friends and I will be very old women with road-map faces. People will read our faces and know where they're going.

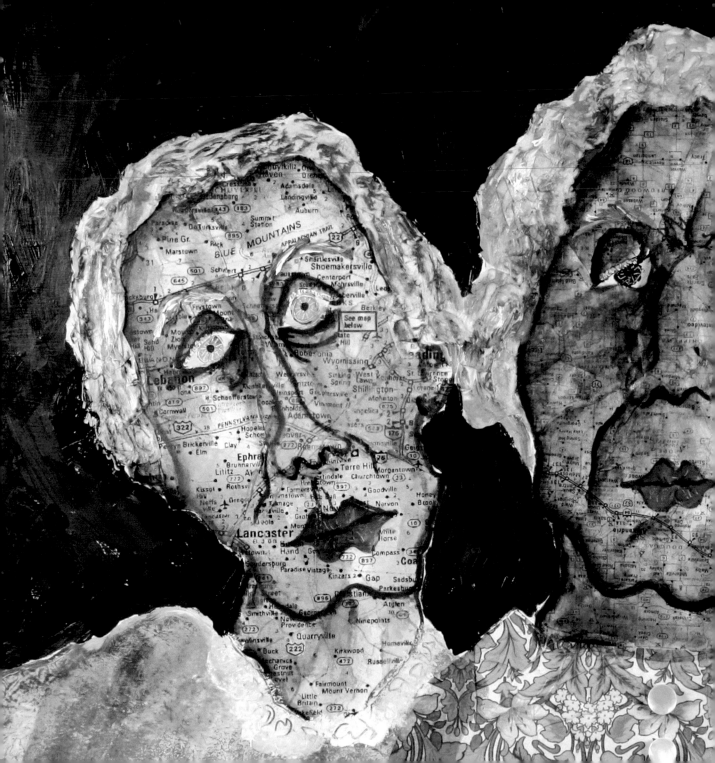

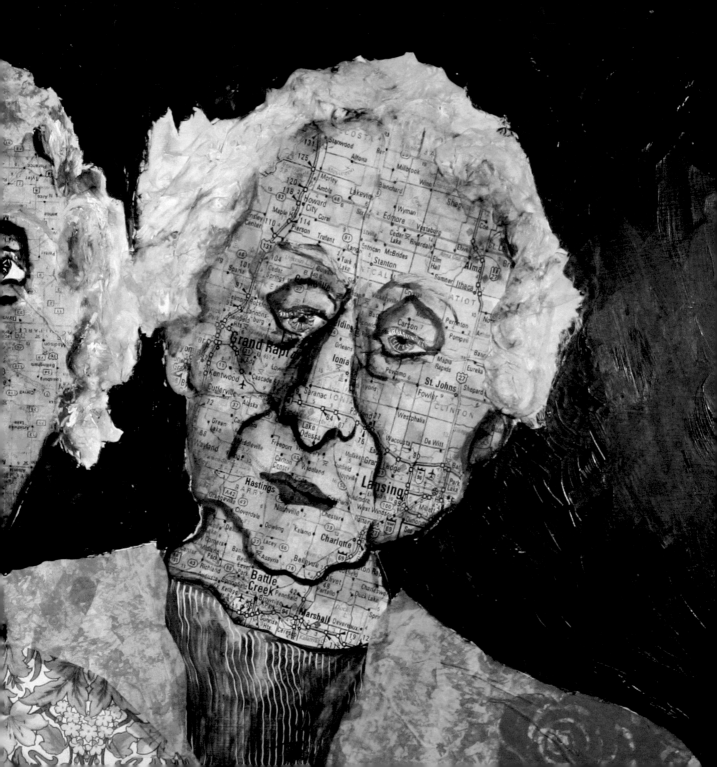

Sleep has become elusive.

It's 2 a.m. . . . 3 a.m. . . . 4 a.m.

I'm not alone.

There is a whole village of us—women about my age—
wakeful through the night.

You can see our yellow lights shining.

Together, we are a sisterhood of sleeplessness.

I've begun losing words, especially proper nouns.

Names of people and places and ordinary words float around and away.

I'm reluctant to make introductions.

In the middle of a sentence, I might forget the name of a good friend.

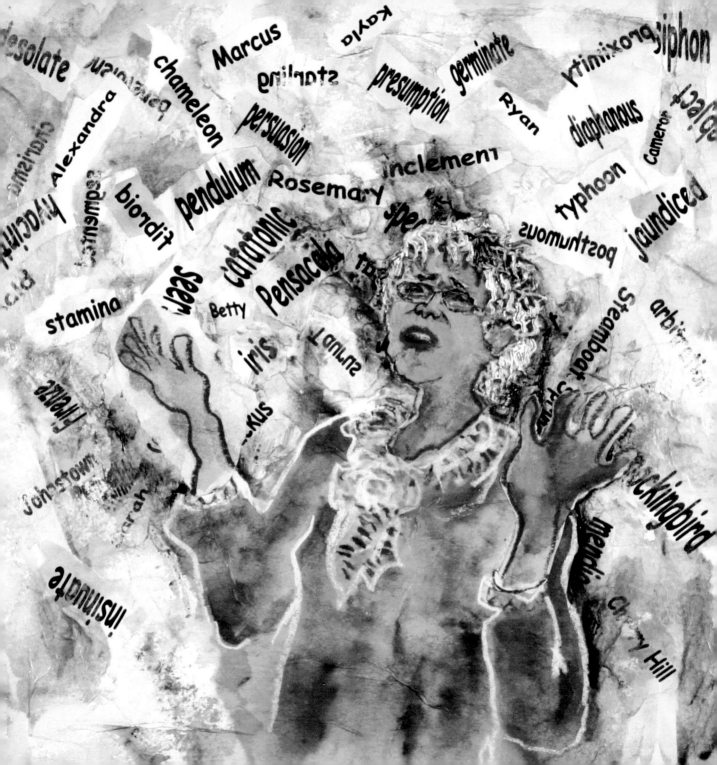

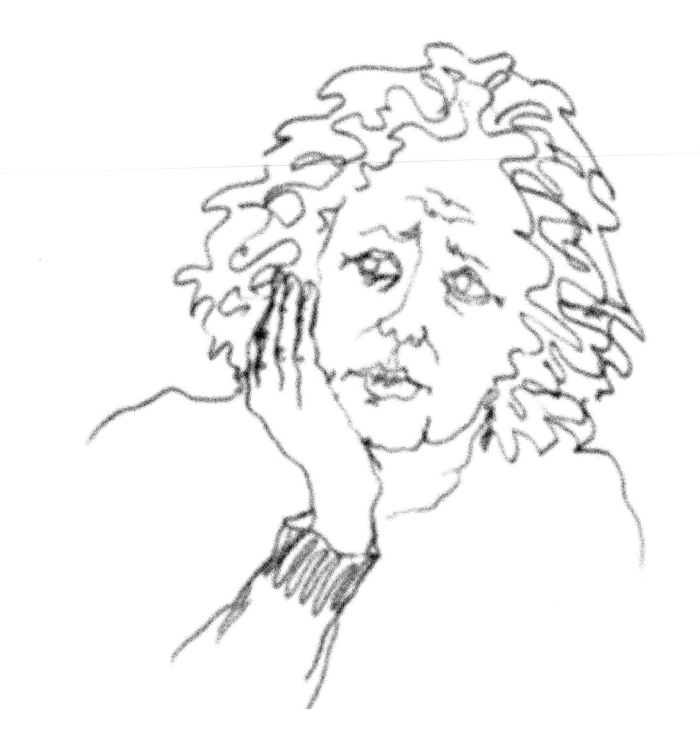

I'm afraid: This could be the beginning of the unraveling of my mind.

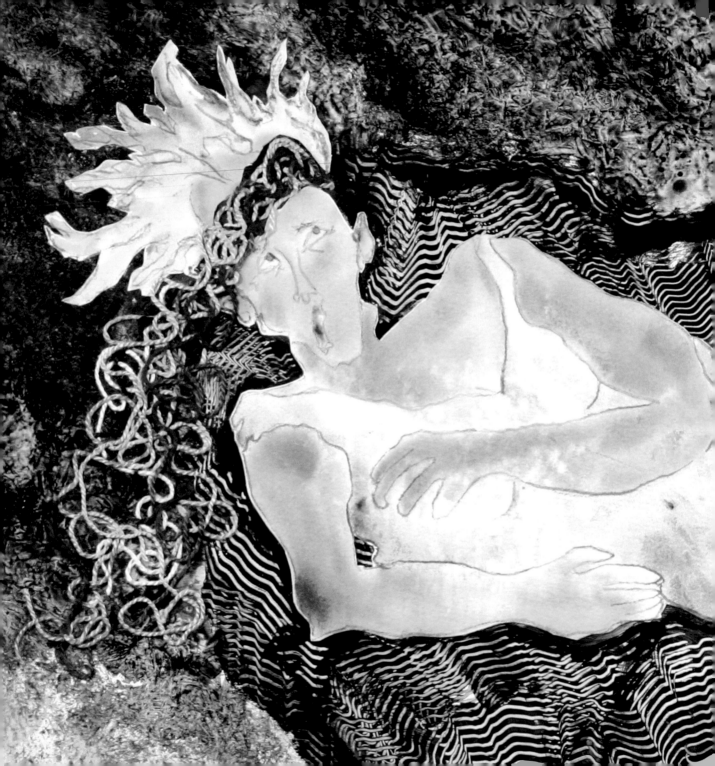

I see ahead of me a black hole . . .

What part of myself will I relinquish?

What function will I surrender?

Which friend or dear one will disappear into the void?

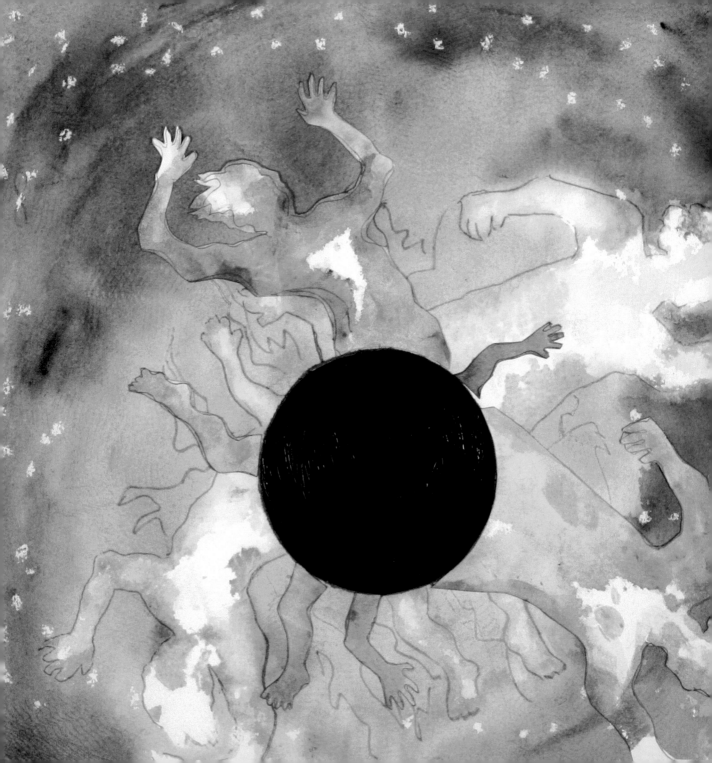

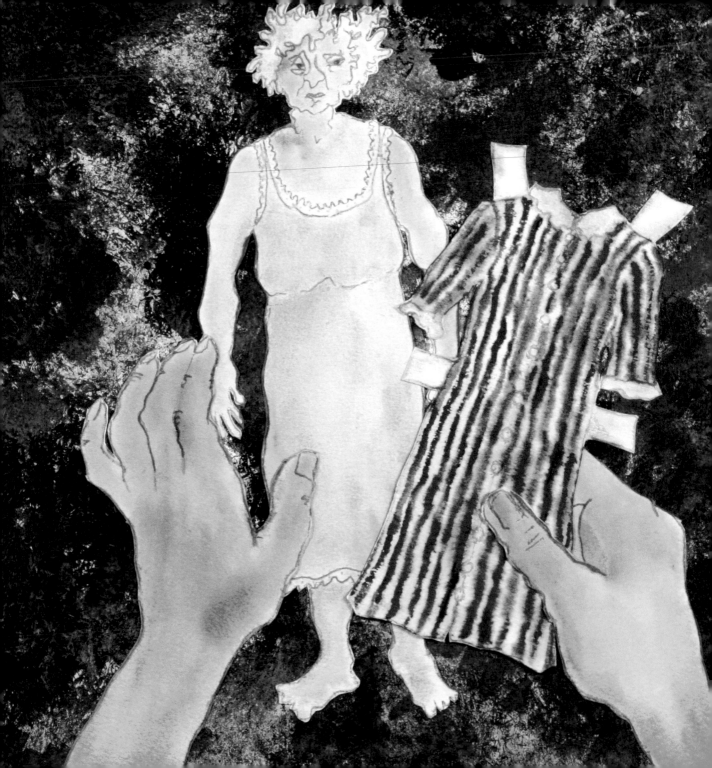

Someday—if my mind wanders off forever,

and my skin becomes like paper,

and my body turns feeble and frail

—I hope there will be kind hands to dress and care for me.

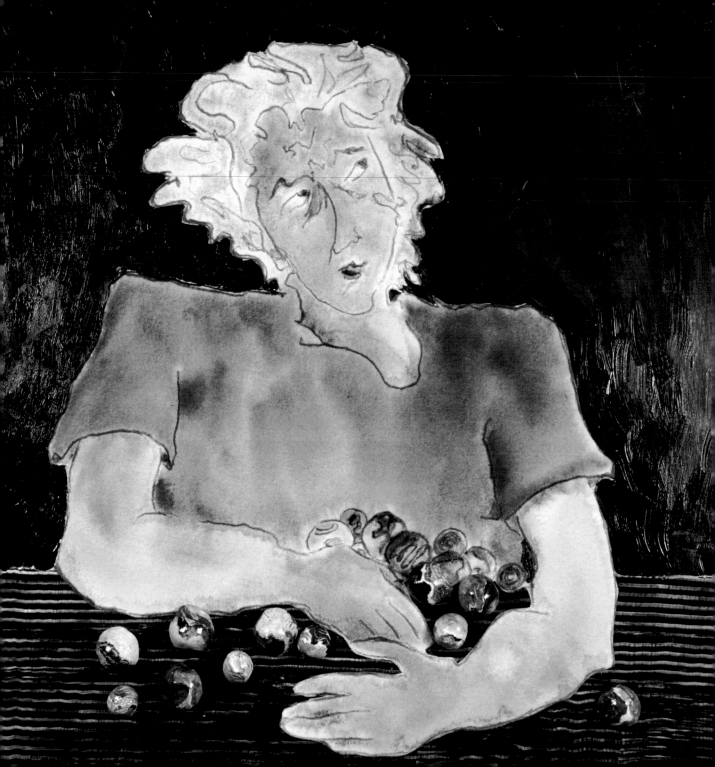

But, at least for now, I still have all my marbles!

I own a richness of years, layers upon layers.

The moments of my life resonate . . .

> gathering trumpet-shaped seashells on wet sand
>
> reading Shakespeare with my brother
>
> eating Mother's cherry cheesecake
>
> choking with grief at her grave
>
> walking in the rain with my love
>
> dancing on stones at our son's wedding
>
> savoring gelato in Rome
>
> playing giggle games with my grandchildren

Some moments come to me as wafts of memory.

But even the myriad moments that have slipped from memory are still mine, incorporated into my cells, into my soul.

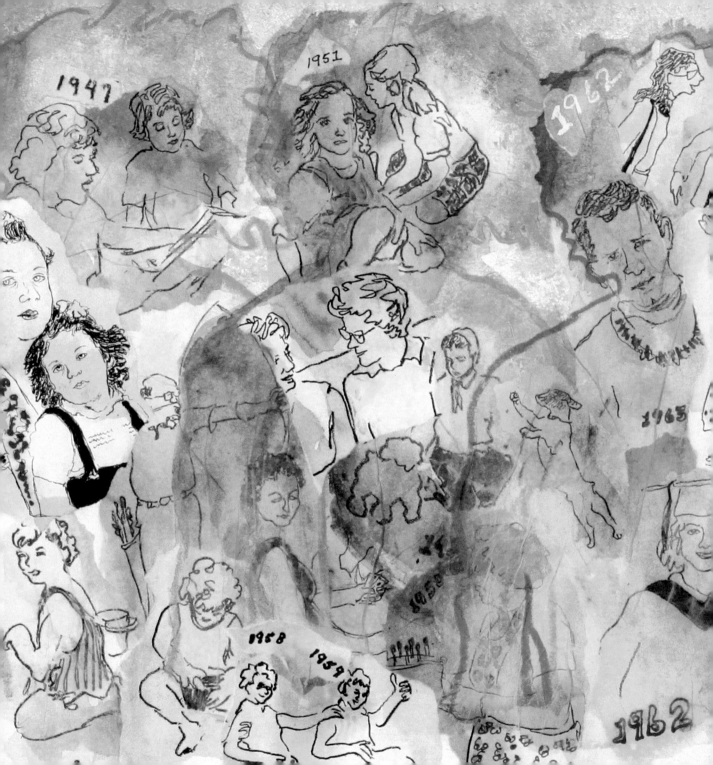

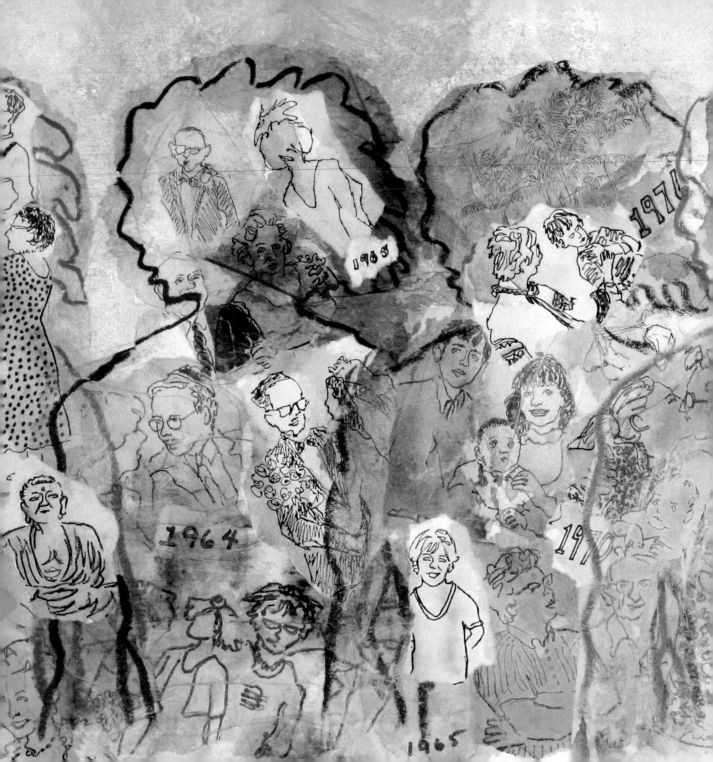

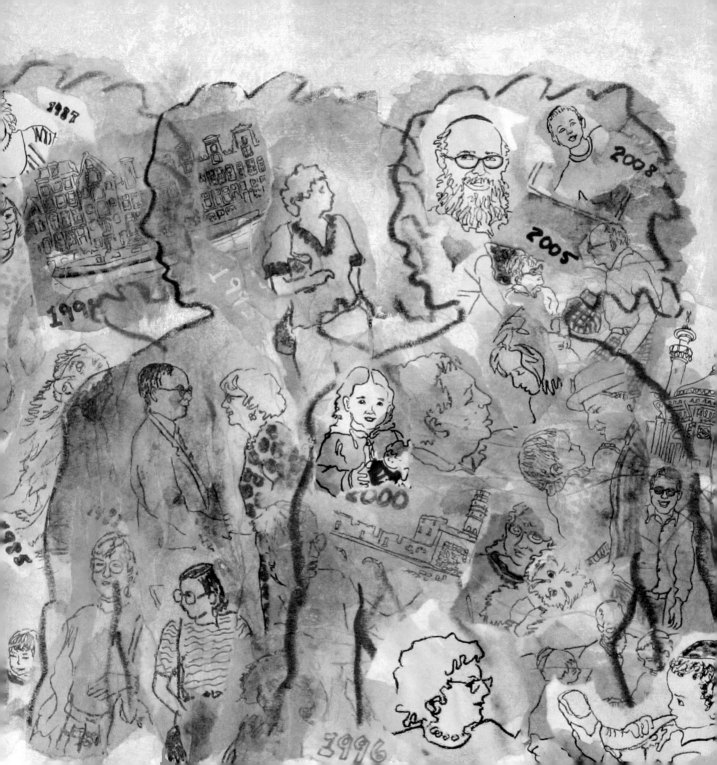

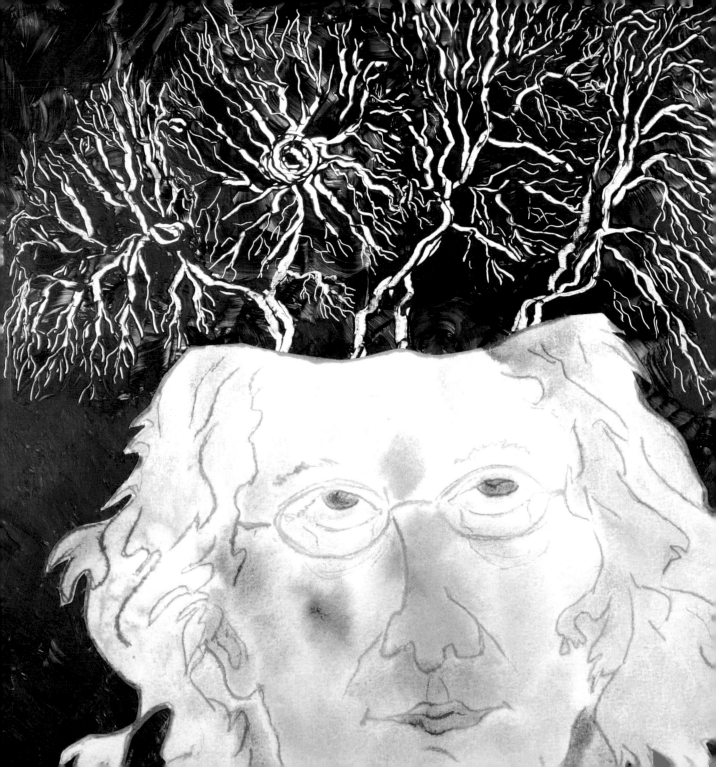

I'm regenerating my brain, growing dendrites.

Nascent thoughts, new-sprung ideas, and odd schemes swirl and spin.

I'm a forever-student.

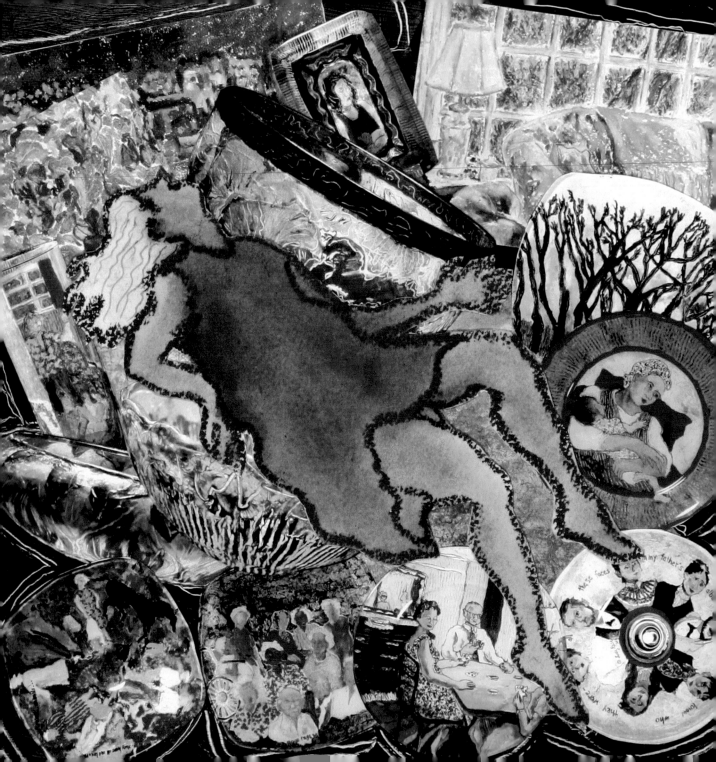

I'm launching a new life as an artist, painting upside down and backward on glass bowls, vases, and plates.

I'm giving re-birth to my self: luminous colors spill out of me.

I bear visions, images, art . . .

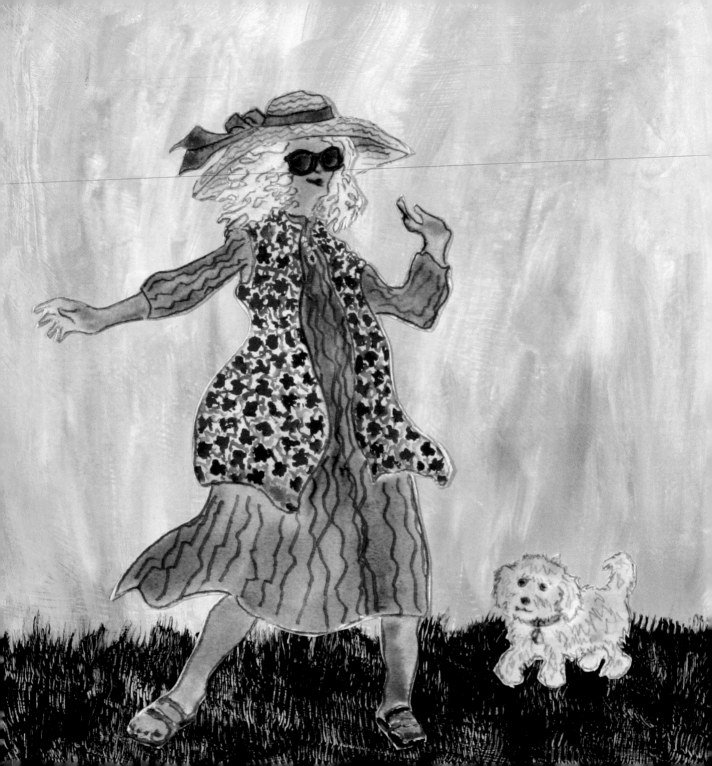

I wear baggy clothes with reckless colors and paint stains.

My long silver hair flies in the wind.

I talk to myself and whisper secrets to my dog.

I construct a list of family members and friends—
women and some men, too, who have gone before me on this journey—
people I admire.

Some are artists, writers, entrepreneurs, scholars, rabble-rousers.

Some are just wise in their own ways.

They are all my models and guides.

I dance in their footsteps.

Aunt Channie C. takes flight in a balloon.

My cousin, Maryse, turning 83, publishes 5 books

At 84, poet and liturgist Ruth B. publishes her first novel.

Connie G. teaches the world about conscious aging.

Jody S. paints poignant pastel portraits.

My sister, Nancy R., charms the universe.

Jerry S. is rich in stories.

Milton K., in his 90s, studies English literature.

Jan H. changes the world.

Gene F., my father-in-law grows tomatoes/studies Talmud.

My mother-in-law, Marian F., illumines the earth with her art.

Abner M. puzzles over provocative questions.

Estelle B., my cousin, knows when to serve a good cup of tea.

Rosalie B. crochets shawls by the seashore,

Gertie A. talks with God.

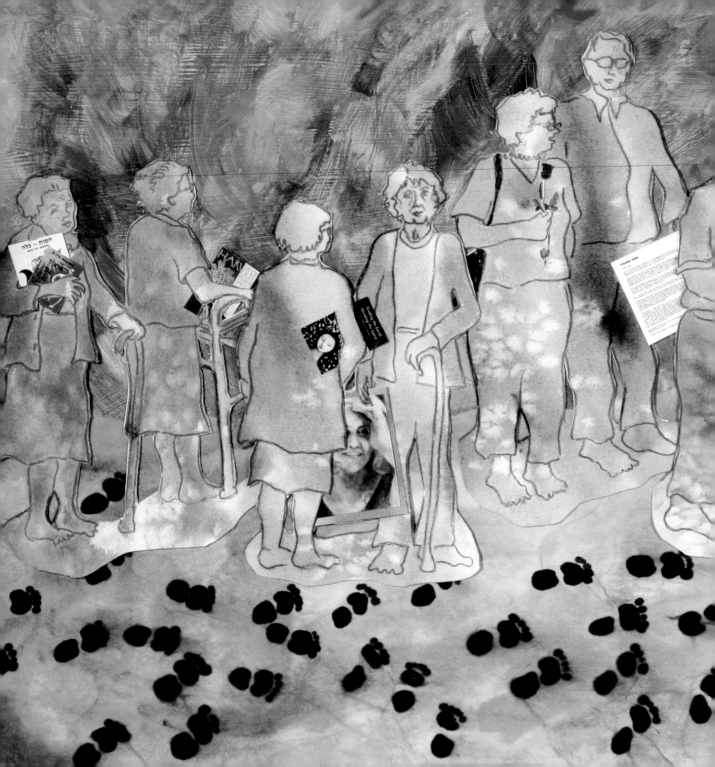

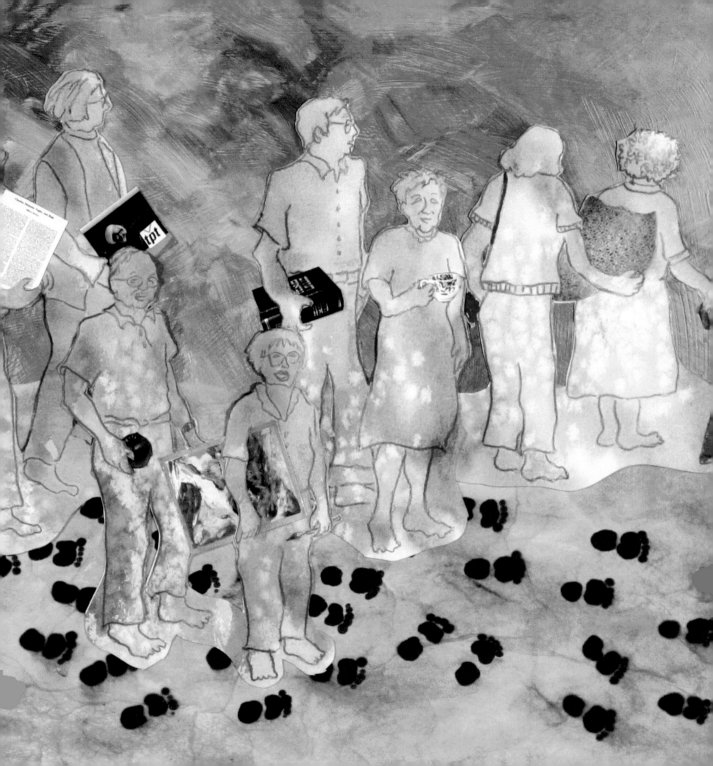

I'm in transition—new at being old.

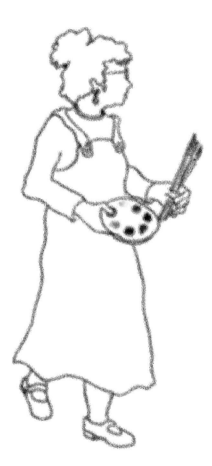

Gingerly, I join the World of Older Women.

We are in cities, towns, and
villages all around the Earth—
a hundred million of us, and more.

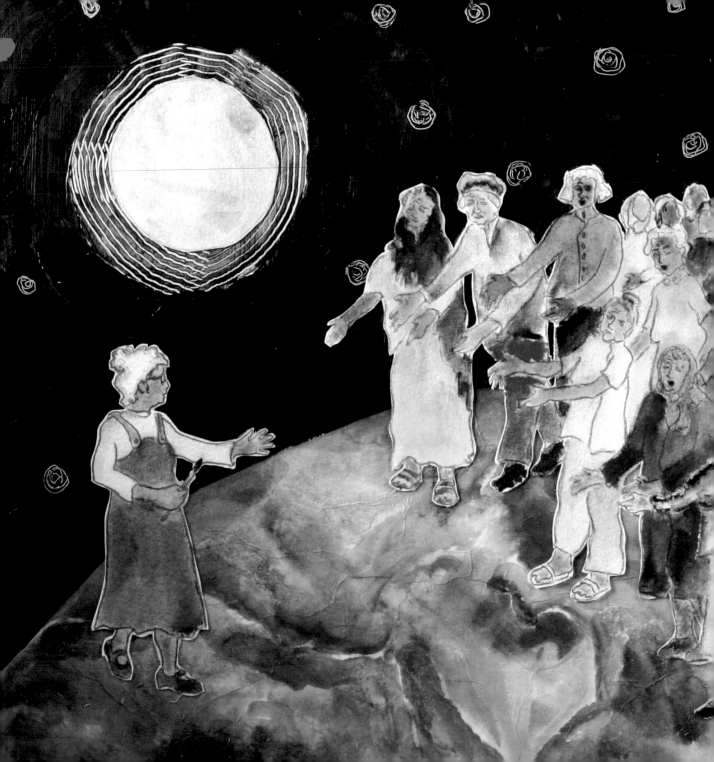

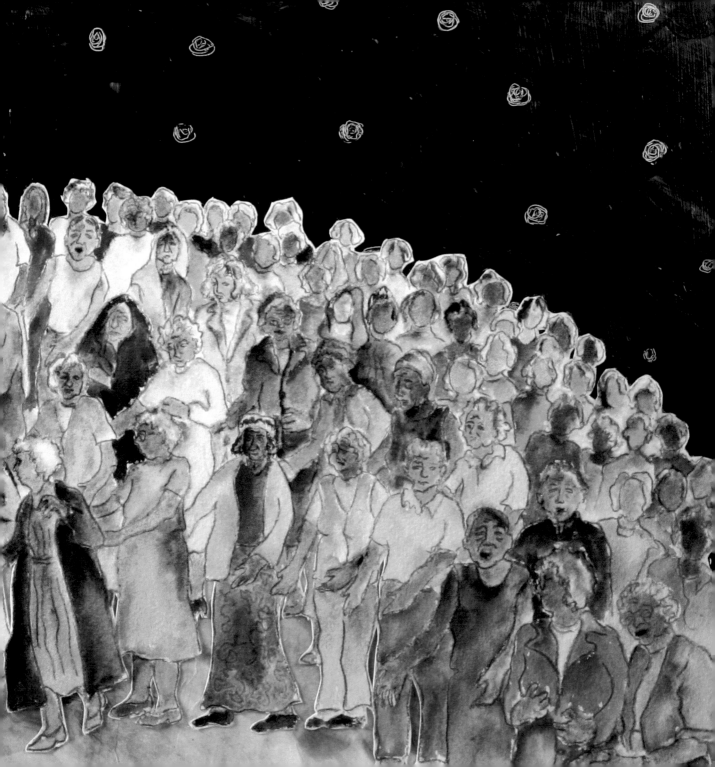

What will I be as I grow old and older?

Who will I be?

I'm just coming of age.

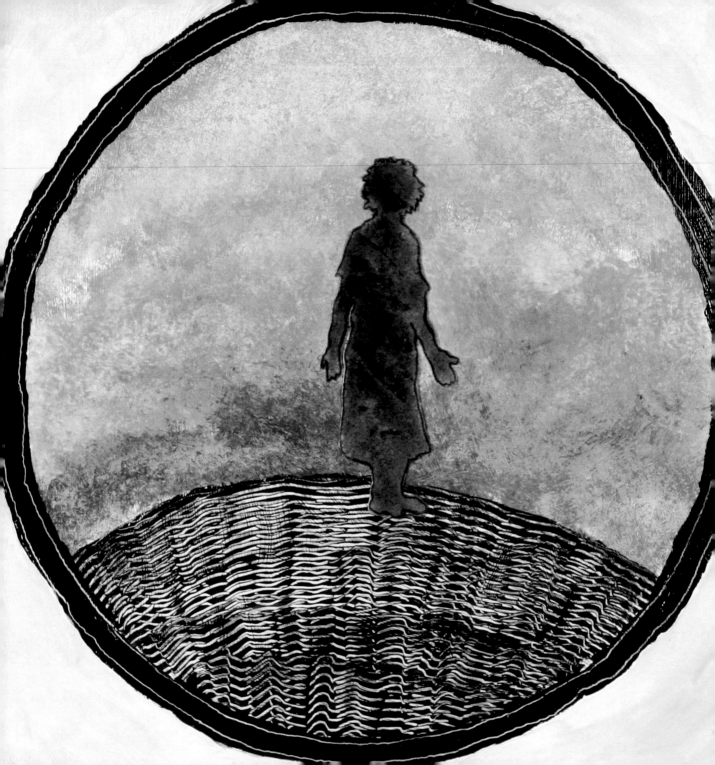

Acknowledgments

My first thank-you goes to Mark Fischer—my husband, my partner, my love—who has given me support and guidance in this project and in many other personal and professional ventures over the four and a half decades of our lives together. Many other hands have helped shape this book. Among those who have reviewed earlier drafts, given me advice, and contributed in various ways are: Dale Anderson, Jim Bindas, Nancy Brown, Melody Chestler and her Devakut group, Alexandra Cooper, Phil Freshman, Sheyna Galyan, Connie Goldman, Bette Globus Goodman, Barbara Rubin Greenberg, Jackie Heilicher and our new writing group, Rachel Holscher, Helen Kivnick, Sid Konikoff, Marcia Marcus, Bruce Nemer, Kerin O'Connor and her writing/art group, Debra Orenstein, the late Will Powers, Pat Samples, Bernie Saunders, Karen Searle, Jerry Siegel, Jody Stadler, Joni Sussman, Erica Walker, and Linda Zlotnick.

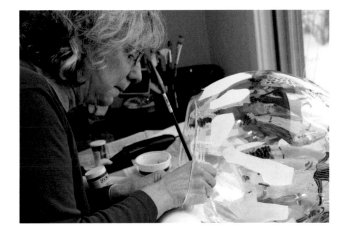

Lucy Rose Fischer, Ph.D., was for 25 years an award-winning researcher specializing in the study of aging. She directed numerous research studies, authored three books, and contributed some 100 articles to professional journals. She was honored as a Fellow of the Gerontological Society of America for her "outstanding achievement and exemplary contributions to the field of aging." Art had always been her passion-on-the-side. Approaching 60, she asked herself, "How old do I have to be to follow my dream?" She then embarked on a second career as artist, developing her own technique for creating vibrant images on glass—painting upside down, inside out, and backward on hand-blown bowls and vases. Her work has been featured in more than 50 exhibitions in the Midwest, Europe, and Israel.

www.lucyrosedesigns.com

Life is a work of art.
Art is a work of life.